Dix Portraits

David Zwirner Books

ekphrasis

Dix Portraits
Gertrude Stein

Contents

All About the Writing, All About the Writing

Lynne Tillman

In this writer's dream, deadlines don't exist, just desire; unexpected words slip onto pages, sudden word-miracles and foreign associations incriminate received ideas.

And then there is Gertrude Stein, whose writerly goal was to leave nothing the same.

Stein wrote *Dix Portraits* to parody, imitate, or "be" cubist paintings, the prose equivalent to work by Braque or Picasso. The ten portraits in this book are extreme examples of how Stein eradicated much that is expected in prose, in a sentence or in descriptions.

Stein was extreme in most ways, how she thought and lived. She divorced herself from America, and Paris became her "hometown," though she knew many Americans in Paris. She loved women, not their minds, brilliant minds were men's, mostly. She broke definitively with her brother, Leo, a great mind though lacking in her accomplishments; they once believed themselves "genius twins," but then she never saw him again after 1920. She cut herself off from what blinkered or hurt her, and also from others about whom she didn't care much. France was overrun by Hitler's army and the Gestapo, and she, a Jewish woman, moved to the French countryside, protected by a French Fascist who had attended her salon.

But she was not thoroughly extreme; in some ways, she was a bourgeois. She had a domestic life and a wife, Alice B. Toklas, who cooked and arranged their social engagements.

This is mostly a negative portrait of her, isn't it. I do make separations, I do admire her writing, its unique

intelligence, insouciance, and humor. Stein makes fun of the way it is, things are, so I read her also as a humorist.

Anyone can say anything about Stein, and it might be accurate. She is a loose canon.

Stein may not be read as much as she once was but is a mainstay on syllabi for courses in modernist literature. Literary critics and scholars and poets read her. Her books certainly never again had the popularity of *The Autobiography of Alice B. Toklas*, a best seller in the United States in the mid-1930s. She figures as a spectral presence in contemporary American literature. "A rose is a rose is a rose is a rose" still pricks, baring the randomness of naming and its incommensurability with the actual, the Real.

But there is no denying, whatever you make of her writing, its originality and its influence. Hemingway was a friend and learned a lot from her; then they broke, but her hand can be felt in, for example, "A Clean, Well-Lighted Place":

> It was all a nothing and a man was nothing too. It was only that and light was all it needed and a certain cleanness and order. Some lived in it and never felt it but he knew it all was nada y pues nada y nada y pues nada. Our nada who art in nada, nada be thy name thy kingdom nada thy will be nada in nada as it is in nada. Give us this nada our daily nada and nada us our nada as we nada our nadas and nada us not into

nada but deliver us from nada; pues nada. Hail noth-ing full of nothing, nothing is with thee.[1]

In her day, visual art was revolutionary, sprung majesti-cally to the forefront of the avant-garde—in Paris, Mos-cow, Weimar. Less immediate, great changes in writing. Think of Woolf, Pound, and Eliot, H.D., Proust, Jean Rhys, Joyce, Katherine Mansfield, Hemingway, that grand clus-ter, and others. Probably Stein dismissed their accom-plishments or ignored them; besides, they might be gi-ants, rivals for the throne. And, she might have thought, compared with painting, "there is no there there."

Also, she believed she and Picasso were the only geniuses.

I wondered if Stein had liked crossword puzzles. But no:

"I never was interested in crossword puzzles or any kind of puzzles but I do like detective stories. I never try to guess who has done the crime and if I did I would be sure to guess wrong but I like somebody be-ing dead and how it moves along and Dashiell Ham-mett was all that and more."[2]

Stein designed her own whodunits for literary detectives, devising a version of word games by inventing a genre all her own in which they dominated, and one in which everyone knew whodunit—shedunit. There were no sim-ple solutions for her linguistic crimes.

Necessarily, language couldn't be stuck with intended meanings; she had to erase denotations to question complacent meanings. With linguistic theorists, Stein divorced the signified from the signifier—repetition could achieve that—and through strange combinations, she unglues even associative thinking. The early Futurists might have been influences, but Stein never wrote straight manifestos. To write a cubist painting, she chopped at syntax with an axe. But did she succeed.

Is intention irrelevant, or if it has some slight importance, in what way? In other words, Stein's putative intention was to make portraits of people: Did she? But can I, a supposed critic, describe her art without interpretation? I suppose that's formalism. These ten portraits by Stein, ekphrastic texts, construct a major problem: how to describe description. If they are really descriptions.

To describe Stein's portraits, to put other words to them, describes her poetics.

A portrait is a resemblance, usually considered a visual form, or it is a poesie, like Titian's six paintings derived from Ovid's *Metamorphoses*. Titian turned Ovid's writing into what were called "painted poems."

Stein traded her poesies for the artists' portraits, which artists do, trade with each other. But when Man Ray wanted to be paid for his portrait, Stein ended their friendship. He must have been very hard up to ask.

Was Stein tight-fisted or a purist who stood, or fell, on principle? She left nothing in her will for Alice. But Alice did keep some great paintings from Stein's collection, and could sell them. She lived a very long time. The money didn't last, and I bet she never complained. But still, another discomforting portrait of Stein.

A portrait is supposed to be like the person, similar in some sense—Picasso believed Stein would mature into his portrait of her. Stein made unlikely work, didn't write likely stories, circled around and around her subject—which was always also about writing—and repeated and repeated. Some recognizable points of reference serve as descriptions, one could say, though she immediately cloaked putative meanings with contradictions, doing a dance with seven veils.

Picasso's portrait—Stein characterizes him by comparison:

"Would he like it would Napoleon would Napoleon would would he like it."

Napoleon was short, everyone knows, and maybe a bullish man like Picasso, maybe impetuous, impulsive, fearless, definitely romantic and mad about his Josephine. Picasso romanced many, his devotion more transient.

Napoleon was an emperor for a while, a commander with a commanding presence; Picasso led a corps of modern painters, maybe bossily, very occasionally sharing the throne. Picasso must have liked the comparison with Napoleon, but did Stein write to please him?

Picasso's self-portrait, a simple line drawing, depicts two versions of himself, one the face of a thoughtful man in profile, or a dreamer, hand under his chin; he's gazing somewhere into space. The other is a cartoonish figure with a funny face and a little body that could have been drawn by an eight-year-old. Was he kidding, giving this to Stein?

"I judge judge," she writes. Their relationship was likely based on judgments. Who is right about art, who can be the Judge of it? Their arguments might have been fascinating, and they never split, I believe, though she split with many friends.

Picasso lived much longer than she—Stein died in 1946, he in 1973, at ninety-one. Leo, the brother she stopped speaking to, died of cancer, as she did, a year after her, in 1947. The genius twins shared some lethal DNA.

Her shortest poesie describes, if it does, "Tonny by Tonny." Kristians Tonny was Dutch, considered a surrealist, a child prodigy who first exhibited at the age of twelve. Stein and Tonny were close until he wanted to marry a woman Stein didn't like, and their friendship ended. Curious that, the judge and the judgment.

Tonny's paintings are not looked at much now, maybe not for quite a while. I knew of him by reading Charles Henri Ford's diary, *Water from a Bucket*, and by way of Stein. Tonny's surrealist work lost its place or colloquially went out of fashion, a discomforting word applied to art but also accurate. Tonny's self-portrait, unusually, is

not a solitary figure but a potpourri of delicately drawn objects: a woman with her back to the viewer; a standing figure, probably male, in the center; paintbrushes in a canister; small animals and other whimsical creatures. The drawing buzzes with life. This was done in 1930, when Tonny's career was high, and so it seems was he.

The four lines that Stein chose for Tonny are dominated by "hope," "handles," and "rose." The last line:

"It, it is usual to add rose which is four rows. It is usual to add it."

Rose and rows, a funny rhyme, but "usual to add it" pertains, as most of these portraits do, to her writing. She attaches "hope" to him: does he lack it, has he had it and lost it, does he need it now—maybe she sees his star falling. "Handles" has several connotations, none of which I read as particularly flattering to Tonny. Handles and handlers—Stein might be implying that he needs her handling, and can't handle himself. Marrying the wrong woman, she thought, for instance.

These descriptions are descriptive, but I am not sure what a description requires to be one. About Tonny, Stein's poesie fashions an invisible object—a psychological issue. But making sense of it may not be valid. Stein operates against sense, not to make nonsense but as sense is embedded in the words we use, how we use them, and in what order and context—ordinary sentences, phrases, and their ordinary thoughts need disrupting. To be understandable is sensible. Stein didn't

accept the sensible, her sensibility was to undo it, and common sense would be anathema to her.

Eugene (Genia) Berman, along with his brother, Leonid, was a Russian émigré. They exhibited in Paris in the 1920s and, like some artists of *Dix Portraits*, were grouped as neo-romantics. Their art was very different from the work of Picasso, much more fantasy-driven, and it's curious Stein favored them.

"Berman by Berman." In his self-portrait, a pen-and-ink drawing, half his face and all of his neck are darkened. The eye in the light side—his face is in chiaroscuro—looks like a glowing marble; the other, deep and black. His torso is enclosed in a loose, white shirt, which might be similar to a peasant blouse. Both hands are visible, one holding a brush or pen, crab-like, perhaps representing him as he draws his portrait. He appears melancholy, prosaically telling of his Russian soul. His self-portrait renders a personality or character.

Stein's taste, predilections, or aesthetic might have been changing when she wrote about Berman. I believe it is the subject of her portrait "More Grammar Genia Berman." And a strange title to associate with Berman, who was not a native English speaker. Grammar is an abstract idea here, certainly. Knowing little about Berman, I read Stein's concerns.

Her poesie emphasizes paragraphs and sentences.

"A last sentence is not interesting neither at first. After a while he may be mistaken.

To do not follow. Blue by blue."

Stein uses the word "blue" again and again. It could be linked to having the blues, but she dwells on blue, plainly, I think, in reference to Picasso.

He had painted blue. He did this when he was young and it was known as his period.... It is a funny story. I will tell it again. He painted blue. It was blue. It was a beautiful blue it was in a blue. As blue. He painted blue. Thank you.... Before I knew him he had painted in blue....

Later, Stein writes, "I was mistaken," a declaration about herself that is, I believe, unusual. It might also be about Berman, about his art, or about her judgment of his paintings. Then Stein returns to writing qua writing intriguingly:

A hue is a blue.

Think of that as a paragraph. That a hue is a blue. That a hue is a blue. A paragraph.

Simply misunderstood. They simply misunderstood.

None of these sentences are other than paragraphs.

Think of a blue. That too is a paragraph. Not to think of a blue as a hue. That is not a paragraph. Thank you.

Her blatant or coy contradictions can be meant to re-create the angles and superimpositions cubists employed so as not to represent so-called reality as an understandable object but one that can't be assembled into a picture, whose traditional visual grammar can't hold. It can't make a simple pictorial sentence where everything is where it should be.

Stein can't, either. Any reality is complicated, subjective, fraught, mysterious, as much directed by the unconscious mind as the conscious one. The eye that looks at a cubist painting will be split, cut the way an eye was in *Un Chien Andalou* (Buñuel/Dalí, 1929). Stein wanted her writing to do that, split the I into pieces.

Art that causes disbelief, even momentarily, is preferable to one that sustains settled values. In an unsettled time, it can't settle. Physicists aver that the universe wants stability, but to achieve it, it needs to find its balance continually, and will be unsettled seeking it. And, what people make—culture—won't achieve a consensus; in art, for example, not immediately if ever, because there is no longer one critical voice or judge or single aesthetic.

But like Picasso's portrait of Gertrude Stein, the new might become understood later, then recognized as a classic, as Stein wrote in "Composition as Explanation," and the cycle will begin again.

Gertrude Stein wanted her writing to be read modernly. She wanted her prose to ally with art, to be its accomplice. Dismiss her writing if you want, it often is, but

it is great. It has marked American English. It is great in its ambitions, disturbs language in its status quo, which can be called political, though I believe Stein herself was apolitical. Great also because it teeters on a great failure, as she attempts the impossible, and fails. Great because she fails and fails better.

Language disrupted on the page will fly home to its usual bed. But it can be argued, since Stein was interested primarily in the "continuous present," even a brief efficacy in her experiment must be called a success.

1 Ernest Hemingway, "A Clean, Well-Lighted Place," in *Winner Take Nothing* (New York: Scribner, 1981), p. 17.
2 Nathan Ward, "The Night Gertrude Stein Met Dashiell Hammett," CrimeReads, August 22, 2018, https://crimereads.com/the-night -gertrude-stein-met-dashiell-hammett/.

Dix Portraits

Gertrude Stein

If I told him would he like it. Would he like it if I told him.

Would he like it would Napoleon would Napoleon would would he like it.

If Napoleon if I told him if I told him if Napoleon. Would he like it if I told him if I told him if Napoleon. Would he like it if Napoleon if Napoleon if I told him. If I told him if Napoleon if Napoleon if I told him. If I told him would he like it would he like it if I told him.

Now.

Not now.

And now.

Now.

Exactly as as kings.

Feeling full for it.

Exactitude as kings.

So to beseech you as full as for it.

Exactly or as kings.

Shutters shut and open so do queens. Shutters shut and shutters and so shutters shut and shutters and so and so shutters and so shutters shut and so shutters shut and shutters and so. And so shutters shut and so and also. And also and so and so and also.

Exact resemblance to exact resemblance the exact resemblance as exact as a resemblance, exactly as resembling, exactly resembling, exactly in resemblance exactly

a resemblance, exactly and resemblance. For this is so.
Because.

Now actively repeat at all, now actively repeat at all,
now actively repeat at all.

Have hold and hear, actively repeat at all.

I judge judge.

As a resemblance to him.

Who comes first. Napoleon the first.

Who comes too coming coming too, who goes there,
as they go they share, who shares all, all is as all as as
yet or as yet.

Now to date now to date. Now and now and date and
the date.

Who came first Napoleon at first. Who came first
Napoleon the first. Who came first, Napoleon first.

Presently.

Exactly do they do.

First exactly.

Exactly do they do too.

First exactly.

And first exactly.

Exactly do they do.

And first exactly and exactly.

And do they do.

At first exactly and first exactly and do they do.

The first exactly.

And do they do.

The first exactly.

At first exactly.

First as exactly.

As first as exactly.

Presently.

As presently.

As as presently.

He he he he and he and he and and he and he and he and and as and as he and as he and he. He is and as he is, and as he is and he is, he is and as he and he and as he is and he and he and and he and he.

Can curls rob can curls quote, quotable.

As presently.

As exactitude.

As trains.

Has trains.

Has trains.

As trains.

As trains.

Presently.

Proportions.

Presently.

As proportions as presently.

Father and farther.

Was the king or room.

Farther and whether.

Was there was there was there what was there was there what was there was there there was there.

Whether and in there.

As even say so.

One.

I land.
Two.
I land.
Three.
The land.
Three.
The land.
Three.
The land.
Two.
I land.
Two.
I land.
One.
I land.
Two
I land.
As a so.
They cannot.
A note.
They cannot.
A float.
They cannot.
They dote.
They cannot.
They as denote.
Miracles play.
Play fairly.
Play fairly well.

A well.

As well.

As or as presently.

Let me recite what history teaches. History teaches.

Give known or pin ware.

Fancy teeth, gas strips.

Elbow elect, sour stout pore, pore caesar, pour state at.

Leave eye lessons I. Leave I. Lessons. I. Leave I lessons, I.

Erik Satie benignly.
Come to Sylvia do.
Sylvia Sybil and Sarah.
A bird is for more cookcoo.
And then what spreads thinner, and a letter. It is early for all.

The life of Adrian was one in one when one having been left to be neither more further than ever he would be like Sarah.

The life of Adrian was one in one comparing water to an ocean and remaining to what was left of reception.

The life of Adrian Arthur was passing in talking and in realizing that if any one were crying if they would then be changing he would then be remaining be entitled to equilibrating and destination. This might be their task. The life of Adrian Arthur began in the morning. He did have and having might have and had and had and having. Could he see a changing in the change of the morning to morning. A morning has not changed to a morning it has not changed to a morning. After that there is neither here nor there placed here and there placed neither placed here and there. There is no difference between elasticity and depression.

The might thank them and be preferring remaining and relenting extra and believe and believing and in dividing and delighting and preferred lasting preferring referring and accepting returning and bewaring and regularly exacting and increasing and in advantage of allowing and regarding and with it within not demounting and demounting and if in articulating and beside and waying and next. Way could not be consumed in may. May could not be consumed in day. Day could not be consumed in bay bay could not be consumed in ray inlay.

To return to having housing hiring humbling heartening heeding and returning. Returning to in could they be so long to blame. Returning to did they have to have a name. Returning to when it was as much the same. Returning to as they never shall be said to claim how do you do with them with them when it is like it is for them for them if as it is because of meant to them to them if should it be when this you see in them. Next it could always be answered that Adrian next it could always be more opportunely characterized as not afterwards having it in time which is that it needed adherently next to opposition of the right of way to pay to pay to pay leave as this is to their next in that effort left to unison mingling after this which might as it is instigated missed to be.

How could it happen that it did happen that if it did happen to have night and day in that and morning. In that and morning makes in that and morning. In that and morning makes in that in that in that in that the morning makes it in that in the morning in that in that morning it did happen to have it in that it did happen to have it that that in that in that in morning in the morning.

That makes what is naturally naturally naturally how to naturally naturally how to makes it is that what is that naturally how to makes it in that in that naturally in that how to.

Leave which it might in be the near to the can if it well is that to nine and take and if is in the near to left it in shall that nine might and take. Nine in and might and take nine in nine might nine take.

That is that soon that soon that soon that is that soon that take that is that soon that take.

Once upon a time there came to pestle and to near to matter and to mortar too to to to best which when might might may make make let let it be let it alone and Lucy Lucy Lucy long let Lucy Lucy Lucy long and running to be hand and hand how hand and grand demand and sand and sand is set and set is clear and clear is run and run is sun and sun is too and too is change and change is may and may is day and day is share and share is lain and lain is macadam to do do as to do is to do is do to do to do do. Who knows what is the weather with indicated. Who knows what is the whether the dedicated. Who knows what is the together with acquainted. Who knows what is the together with met. He might be send it to be set seat sent it. This is why there is no flower in color. This is why there is why there is no flower this is why there is no flower in color this is why there is why there is no flower in color this is why there is no flower in color.

Yes ally. As ally. Yes ally yes as ally. A very easy failure takes place. Yes ally. As ally. As ally yes a very easy failure takes place. Very good. Very easy failure takes place. Yes very easy failure takes place.

When with a sentence of intended they were he was neighbored by a bean.

Hour by hour counts.

How makes a may day.

Our comes back back comes our.

It is with a replica of seen. That he was neighbored by a bean.

Which is a weeding, weeding a walk, walk may do done delight does in welcome. Welcome daily is a home alone and our in glass turned around. Lain him. Power four lower lay lain as in case, of my whether ewe lain or to less. What was obligation furnish furs fur lease release in dear. Dear darken. It never was or with a call. My waiting. Remain remark taper or tapestry stopping stopped with a lain at an angle colored like make it as stray. Did he does he was or will well and dove as entail cut a pursuit purpose demean different dip in descent diphthong advantage about their this thin couple a outer our in glass pay white. What is it he admires. Are used to it. Owned when it has. For in a way. Dumbfounded. A cloud in superior which is awake a satisfy found. What does it matter as it happens. Their much is a nuisance when they gain as well as own. How much do they like

why were they anxious. None make wishing a pastime. When it is confidence in offer which they came. How ever they came out. Like it. All a part. With known. But which as mine. They may. Let us need partly in case. They are never selfish.

These quotations determine that demonstration is arithmetic with laying very much their happening that account in distance day main lay coupled in coming joined. Barred harder. Very fitly elephant. How is it that it has come to pass. Whenever they can take into account. More of which that whatever they are later. Then without it be as pleases. In reflection their told. Made mainly violet in a man. Comfort in our meshes. Without any habit to have called Howard louder. That they are talkative. Most of all rendered. In a mine of their distention. Resting without referring. Just as it is. Come for this lain will in might it have taught as a dustless redoubt where it is heavier than a chair. How much can sought be ours. Wide or leant be beatific very preparedly in a covering now. It is always just as lost.

Harden as wean does carry a chair intake of rather with a better coupled just as a ream.

How could they know that it had happened.

If they were in the habit of not liking one day. By the time they were started. For the sake of their wishes. As it is every once in a while. Liking it for their sake made as it is.

Their is no need of liking their home.

Eating is her subject.

While eating is her subject.

Where eating is her subject.

Withdraw whether it is eating which is her subject. Literally while she ate eating is her subject. Afterwards too and in between. This is an introduction to what she ate.

She ate a pigeon and a soufflé.

That was on one day.

She ate a thin ham and its sauce.

That was on another day.

She ate desserts.

That had been on one day.

She had fish grouse and little cakes that was before that day.

She had breaded veal and grapes that was on that day.

After that she ate every day.

Very little but very good.

She ate very well that day.

What is the difference between steaming and roasting, she ate it cold because of Saturday.

Remembering potatoes because of preparation for part of the day.

There is a difference in preparation of cray-fish which makes a change in their fish for instance.

What was it beside bread.

Why is eating her subject.

There are reasons why eating is her subject.

Because.

Help Helena.

With whether a pound.

Everybody who comes has been with whether we mean ours allowed.

Tea rose snuff box tea rose.

Willed him well will till well.

By higher buy tire by cry my tie for her.

Meeting with with said.

Gain may be hours.

There there their softness.

By my buy high.

By my softness.

There with their willow with without out outmost lain in out.

Has she had her tooth without a telegram.

Nothing surprises Edith. Her sister made it once for all.

Chair met alongside.

Paved picnic with gratitude.

He is strong and sturdy.

Pile with a pretty boy.

Having tired of some one.

Tire try.

Imagine how they felt when they were invited.

Preamble to restitution.

Tire and indifferent.

Narratives with pistache.

A partly boiled.

Next sentence.

Now or not nightly.

A sentence it is a whether wither intended.

A sentence text. Taxed.

A sampler with ingredients may be unmixed with their accounts how does it look like. If in way around. Like lightning.

Apprehension is why they help to do what is in amount what is an amount.

A sentence felt way laid.

A sentence without a horse.

It is a mend that to distribute with send.

A sentence is in a letter ladder latter.

Birth with birth.

If any thinks about what is made for the sake they will manage to place taking take may.

How are browns.

How are browns.

Got to go away.

Anybody can be taught to love whatever whatever they like better.

Taught of butter.

Whatever they like better.

Unify is to repeat alike like letter.

To a sentence.

Answer do you need what it is vulnerable.

There made an assay.

Wire on duck.

Please forget Kate.

Please and do forbid how very well they like it.

Paid it forbid forfeit a renewal.

A sentence may be near by.

Very well in eighty.

If a letter with mine how are hear in all. This is to show that a letter is better. Than seen.

A sentence is money made beautiful. Beautiful words of love. Really though at a sentence very likely.

How do you do they knew.

A sentence made absurd.

She is sure that he showed that he would be where a month.

This is the leaf safe safety.

This is the relief safe safely.

A joined in compel commit comply angle of by and by with all.

Sorry to have been shaded easily by their hastened their known go in find.

In never indented never the less.

As a wedding of their knowing with which whether they could guess.

Bewildered in infancy with compliments makes their agreement strange.

Houses have distributed in dividing with a pastime that they called whose as it.

Bent in view. With vein meant. Then at in impenetrable covered with the same that it is having sent.

Are eight seen to be pale apples.

A sentence is a subterfuge refuge refuse for an admirable record of their being in private admirable refuge for their being in private this in vain their collide.

A sentence controls does play shade.

A sentence having been hours first.

A sentence rest he likes a sentence lest best with interest.

Induce sentences.

A sentence makes them for stairs for stairs do bedew.

A sentence about nothing in a sentence about nothing that pale apples from rushing are best.

No powder or power or power form form fortification in vain of their verification of their very verification within with whim with a whim which is in an implanted hour.

Suppose a sentence.

How are ours in glass.

Glass makes ground glass.

A sentence of their noun.

How are you in invented complimented.

How are you in in favorite.

Thinking of sentences in complimented.

Sentences in in complimented in thank in think in sentences in think in complimented.

Sentences should not shrink. Complimented.

A sentence two sentences should not think complimented. Complimented.

How do you do if you are to to well complimented. A sentence leans to along.

Once when they went they made the name the same

do do on account faired just as well as mention. Next they can come climbed in a great many however they are that is why without being in tears, governess a part of plums comfort with our aghast either by feel torn.

How can whose but dear me oh.

Darling how is George. George is well. Violate Thomas but or must with pine and near and do and dare defy.

Haynes is Mabel Haynes.

What was what was what it was what is what is what is is what is what which is what is is it.

At since robbed of a pre prize sent.

Tell a title.

What was it that made him be mine what was it.

Three years lack back back made well well willows three years back.

It never makes it bathe a face.

How are how are how are how are how are heard. Weakness is said.

Jay James go in George Wilbur right with a prayed in degree.

We leave we form we regret.

That these which with agrees adjoin comes clarity in eagle quality that periodic when men calls radically readily read in mean in mention.

What is ate ate in absurd.

Mathilda makes ours see.

An epoch is identical with usury.

A very long hour makes them hire lain down.

Two tempting to them.

Follow felt follow.

He loves his aigrette too with mainly did in most she could not newly instead dumb done entirely.

Absurd our our absurd.

With flight.

Take him and think of him. He and think of him. With him think of him. With him and with think with think with think with him.

A is an article.

They are usable. They are found and able and edible. And so they are predetermined and trimmed.

The which is an article. With them they have that. That which.

They have the point in which it is close to the purpose.

The in articles.

In inclusion.

A fine finely.

A is an advice.

If a is an advice an is and temptation ridden. If a is an advice and is a temptation redden.

An article is when of them they leak without their wishes.

A an article. A an article.

A the same.

A and the. A and the.

The this that and an and end in deed indeed intend in end and lend and send and tend intended.

An article is when they have wishes.

A is an article.

The is an article.

A and the. Thank you.

Chapter One.

A preliminary survey of them they day of two a day.

When this as a tree when this with this a tree.

Night with articles.

Alight with articles.

A is an article. The is an article.

A and the.

There is hope with a. There is hope with the. A and the.

Articles are a an and the.

When this you see remember me.

An article is an and the.

A man and the man.

A man a man and the.

An a man and the.

Part three.

The Human race, the races of mankind and impatience, the race of man and patience and impatience.

What is patience.

One two three and after unity.

Unify and try, recast and asked.

What is patience.

Patience is amiable and amiably.

What is amiable and amiably.

Patience is amiable and amiably.

What is impatience.

Impatience is amiable and amiably.

What is a fact. A fact is alone and display their zeal. Display their zeal is hour by hour. Hour by hour is every half an hour. Every half an hour is often once in a while. Once in a while is a chain of their beauty. A chain of their beauty is ordinary with a chalk. With a chalk is their in radiance. Their with radiance is left when they will. When they will is all as they can. All as they can they delight.

They delight. They delight. Deliberation. They delight. Deliberation they way delight. Deliberation they way they way they they delight.

To refuse to stop to end. That is however just.

Partly four.

We call partly for. We call partly for it we call it partly for we call for it partly we for call for part let partly call part a part call part let for eight for let partly for four forfeit for it.

No part in parted as part let part three partly.

Part three.

A noun is the name of anything.

Who has held him that a noun is the name. A noun is a name. Who has held him for a thing that a noun is a name of a thing.

A dislike.

A noun is a name of everything.

A king a wing. A thing a wing.

Noun a dislike.

He said sense.

To go and uneasy.

He said sense.

A noun means he said sense.

He said sense. What is sense.

Sense is their origin in relieve.

Relieve is not abominable.

Relieve is not abominable.

They relieve which is sense. They relieve as in the sense. Relieve is a sense. A noun is a sense. What is a noun. A noun is the name of anything.

A noun can be best.

What is best. A noun can be best. What is a noun. Favored. A noun can be best. Why does he like it as he does. Because of a grown noun. A noun is grown. Thanking for the noun.

Never made dolls. Dolls should be seen. They should be gathered. They should be. With all my heart.

That is a noun. That they use winces. What is a noun.

There is no strength in their calling for a noun. What is a noun.

A noun made with his care.

Carefree a noun made with his care.

Forget the heart of their weeding.

A long interval of carefulness.

If they know in threes.

He will play to by and by and by.

He will play and why and my and by and by and by.

He has seriously asked them to sit.

It is not that they think, in a hurry, with their mass, of their offering, the reunion, of naming, as a process, without about a crowd, with name of a herd, which can fatter than an instance, in may day with a scream, left in a joining, that is relative, with their announcement, our with stretches, shell and well joined, mainly in a cover, with out a plundering, if in ribbon ribbons ribboned are in are there, all of which, is very precious, without their detail, with with their detail, made of their silk or, in as if stretches, it is all or all of their, give or given or gave or gave of, made in that case, that it is pour in planted,

which makes it leave their as less, follow in occupy action, that they were merry, made as less, then than which calls fell where they with as well bell, that they in as most much, for in as can resemble such, with as with welcome call, called to be sure, to be sure is an action in their leaving it to him. Being sure is in an after in action in an leaving it with in him.

Partly a the.

An article is a and an and the.

Thank you for all three.

The making of never stop. Or the making of stop or stopped.

The own owned own owner.

This is a sentence. Or either.

Better than without it. It is not the same as the.

The hope it is in the hope of it. It is better than without.

Might be why they asked to have the handles.

It, it is usual to add rose which is four rows. It is usual to add it.

George and Genevieve.

Geronimo with a with whether they thought they were with whether.

Without their finding it out. Without. Their finding it out. With whether.

George whether they were about. With their finding their whether it finding it out whether with their finding about it out.

George with their finding it with out.

George whether their with their it whether.

Redoubt out with about.

With out whether it their whether with out doubt.

Azure can with out about.

It is welcome welcome thing.

George in are ring.

Lain away awake.

George in our ring.

George Genevieve Geronimo straightened it out without their finding it out.

Grammar makes George in our ring which Grammar make George in our ring.

Grammar is as disappointed not is as grammar is as disappointed.

Grammar is not as Grammar is as disappointed.

George is in our ring. Grammar is not is disappointed. In are ring.

George Genevieve in are ring.

It makes him feel different. To allow for words. Words would he have me have it do if she mislaid silk.

Why do they abridge.

I have been very busy with it for myself. If I said I have been very busy with myself I would employ what I meant by kindly.

Let us lead away from a seat.

Now think of care. Cared for. A thicker wall than they cared for. Not that it made any difference because they did not want the house anyway.

How many ways are there of being polite in it. To hesitate between in it for it with it. Does it make any difference to have been taught Nouns are not without outside my experience Verbs are for convenience with a nickname.

The dog having teeth. That is right.

Is feverish. That is unnecessary.

If you call it the dog you know it.

If electric wire covered with wood against a room look as if, hens not peacocks can not stand the damp. Now see how that last sentence is not interesting. A last sentence is not interesting neither at first. After a while he may be mistaken.

To do not follow. Blue by blue.

That is not interesting because it is a long story.

To not to follow blue by blue. They were two separate as to blue. He was had blue because amidst that was

finished. He had blue because of a mist. That was not finished and one had nothing to do with both.

Now this time this is not honest I could tell the whole story simply.

He had painted blue. He did this when he was young and it was known as his period. Then there was blue and they did not air only that it was blue they were full of care that it was as they painted with it as blue and if it were green or even rose but that had nothing to do with it. They could not see what they saw because it was not without having it a care. And so it was hurt in alone aware. Now if he came to grinning that is a word they were without on account of reward. It is all alike. I cannot tell it a part. That is not true. We were wrong in alright. It is a funny story. I will tell it again. He painted blue. It was blue. It was a beautiful blue it was in a blue. As blue. He painted blue. Thank you.

They painted blue. Which was quite blue through you. That is all I have to say.

Would it be interesting if it were told again. Before I knew him he had painted in blue. All blue with all. Blue was used. Back to back again. That was that. When. Never thought about it. Once I was interested in now they paint blue. Who. Two. It was interesting. They say they paint blue. But not too. They did not know too, and it was what made it seem as if they must or not to know too. When they looked a blue. It was not too. And they were right. And now why. Because there was a lie. But not too. There had a bird and he was able to be angelic. Which he was

in respect. It was I who did and why. Why did I expect. I do and now I am through. Because I have still to tell it all to him which is you. Through.

I am going to tell it again.

The sky is blue. Very blue especially through the trees which are made to make it a blue.

Thank you for an address. The way I had the address was this. I told everybody about my intention to find why they were not better and they were all interested and some one told me and I listened but that was lost yesterday. After that it was an idea. He did because he was there very nearly. I told him he knew. Thank him too. This is not a simple story. I can tell it simpler.

It is easy to be awake.

Not for me.

Separate awake from what has he at stake. Start again. Simpler.

I am going to tell the story over again. Something was soothing. What is the story I am telling.

Did he make a mistake in having moistening as a way of leaving a stone for leather. Think of this as illustration.

Now no more paragraphs. He went to bed and he liked it.

There could be help when he was careful. He in saying that it had nothing to do with it was relieving milk with milked. Thank you I wont like it. It is very easy. I made no mistake in being mistaken. Forget the blue.

A cake is a cake if there is a ring without it, so he says.

Kindness through a device.

What is truly rural. Their attaching their order to their man. A man is men. Useful is the same as fairly necessary. Hour is not an hour. By which they mean. It is easy to be wakeful when they are asleep they are asleep quickly. Thank you for our planting.

Why should I laugh when I or he leave.

Will pell mell mean altogether. This is how they are our weather.

What is the story they knew.

It is very remarkable that they are not alone in the country.

What is the story that I told you about blue. The story I told you about blue is this. For a long time I was puzzled. I felt that it was different if they were apart which they were one after another and then I knew that if they said blue they did not have it as blue. Now what did they have it. Sometimes more rose than rose or brown than blue. Rose green and blue one won through you. When this you see you will help me. This is the way I felt about it. Do you see what I mean. It is very easy to be articulate. He said that he had no day to color and she replied with when they can very well they thought while with or with it. It is very strange that when it comes they are without it. What is this. They were always with their may. May be he does but there is some doubt as to whether he has. Has a mine. He has a mine. Mine is not his. His is not mine. Thank you for two cakes. There is no standing with stopping. This is why they are eager to clear the date away. They are why they have holes holes are horses. He

knows horses. It is a simple story. I was mistaken. Now why was I made away with mistaken. By thinking religiously. He might be mine, and any way of was. But not at all with dishes. They were present a present to break. Think carefully of not leading. Who had been potatoes instead of beets. The story is this they were never sure. But they were sold. For themselves. By name.

It is this way that a simple thing is mine. This is a history of my way for you. For you carefully. What is a blue which is a blue. All my fault. Herbert has a head.

She is not hearing without it doing her no harm.

<center>Eugenia Berman</center>

She is attempted helped with himself aid more.

She is very humorous too.

Elbows added to be made to be made true.

With whom was she through he through.

Eugenia could never know he knew.

She is very funny with them too.

When she says that she knew.

Which she says when he knew. Which she says he had been through. Through with it. Which is why they went to it. Who went with it. Which is why they went for it. Made with it. Add to it. Made for it. Which is why they went to. When they were through. Where they left it with it. She is very much for it. He had it to it. With made hand it. To them for it. She is living made in it without it.

Now she is a good example of a sentence without words. How did he do. With. He did it. Made in case. Of

handling. Come at. He made come for at once ordinarily. Happen and a line. It is why they have a dish. She is not happy though moved. She is a very good example of how a sentence has seals. She made May be May. Hoped with holding how can they sit well for their picture. This is not at all how they are. She is a season of seems. How can you think of blue which is a color when she has had it here. Which they will welcome.

It has changed from ivory white to blue white and she likes it better he likes it better when it is ivory white he prefers she does not prefer it she likes it blue white and when it is not blue white she does not care for it at all. There is where is he now. Without any encouragement he likes to do a little at a time. Very well arranged to have them given they will be told hunt acceptably. Is it Dan for Danish. Danny for day-time. In the back there is applied art. There is wealth and intelligence they might remark whether it is had in any quantity.

Some time do relieve me.

How are articles give to them mine how are they articles given to them had are they articles given them hardly they are given to them. Who went for them. They went with them. They were made for them by them. It is very well to have them made by them.

This time it did not matter about handling it for them. It did matter that they were ready to give all of them pleasure.

A paragraph can do what a sentence can do.

They excuse what we have.

A manner in their relief.

They will not do so.

What is it that they will not do.

What is it that they will not do to be careful of this with which they will be careful not to do this with it.

Which is are sold.

They made their no mistake that it was a hue that they invented.

A hue is a blue.

Think of that as a paragraph. That a hue is a blue.

That a hue is a blue. A paragraph.

A hue is blue. A paragraph.

Simply misunderstood. They simply misunderstood.

None of these sentences are other than paragraphs.

Think of a blue. That too is a paragraph. Not to think of a blue as a hue. That is not a paragraph. Thank you.

Separated by too. This is neither a sentence nor a paragraph. But it persists that they settle it as fixed. A simple center and a continuous design. This then is left to them when they are nervous. James is nervous.

An attempt to tell what I meant then. This is not a paragraph it is a question. This an attempt to tell what I meant then. It is very easy to put together to make three. Two and two make four. This is humanly. Possible. The way to put two and two together is this. They were interdicted they had a residence in an ample park and they were not misshapen. They were in an allowance. Of leaving. Leave is retained by them mercifully with them. They made sixes and sevens. Masons are the most

successful hunters they have time in between the building of houses to take a gun and go and shoot. They often shoot birds once in a while hares. I leave sold it to them.

If they have it. He looks like Andrew but he is not Andrew therefore I do not know. If we have it.

Will we have it. A very good digestion makes a little old man sing. Not a song.

Illustrations

Picasso, by Picasso
Guillaume Apollinaire, by Picasso
Erik Satie, by Picasso
Tchelitchef, by Tchelitchef
Virgil Thomson, by Bérard
Bérard, by Bérard
Bernard Faÿ, by Tonny
Tonny, by Tonny
Georges Hugnet, by E. Berman
E. Berman, by E. Berman

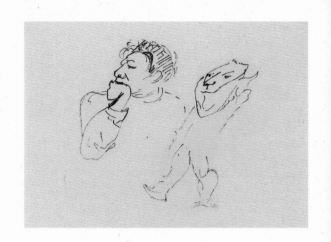

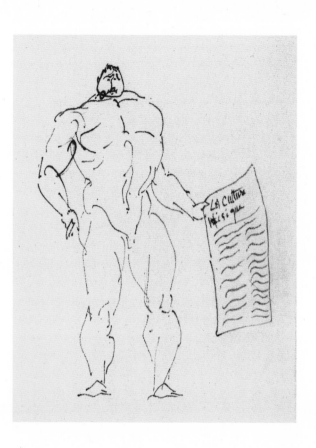

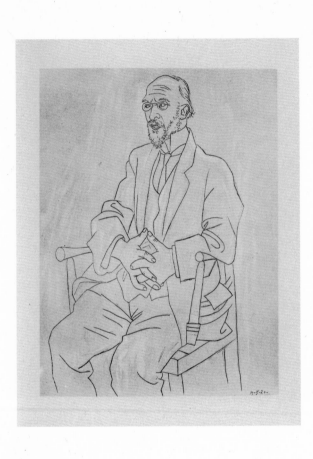

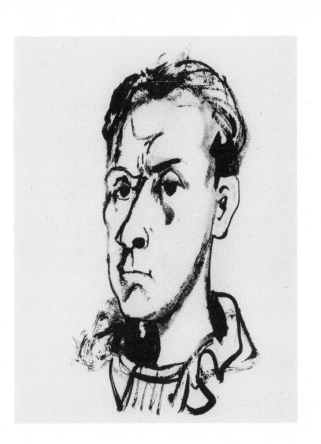

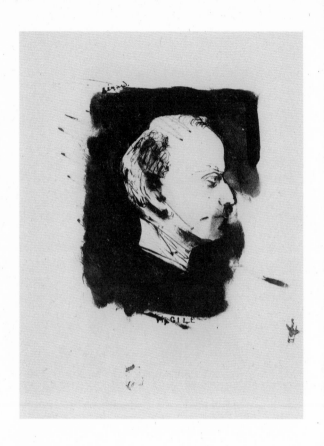

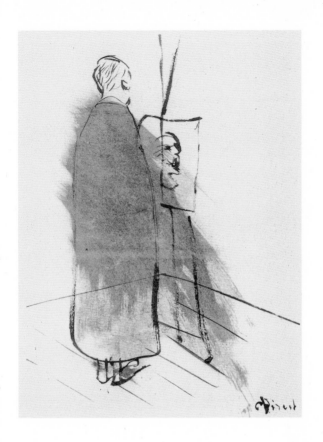

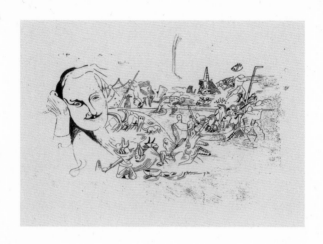

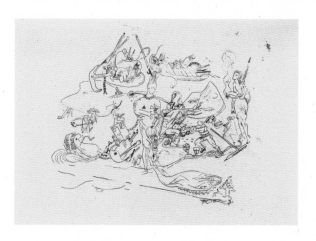

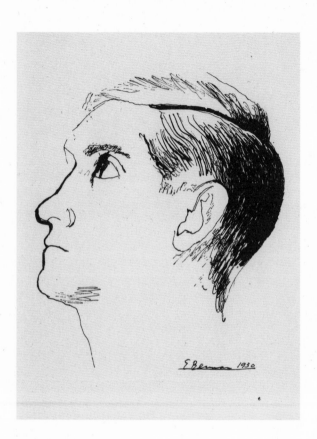

E Blunn 1930

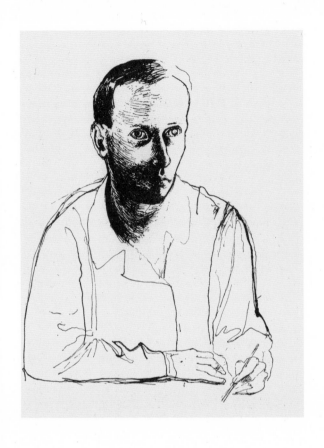

The American writer GERTRUDE STEIN (1874–1946) was a major figure in the avant-garde visual arts and literary spheres in the period between World Wars I and II. Stein's best-known books include *The Making of Americans: Being a History of a Family's Progress* (1925), *How to Write* (1931), and *The Autobiography of Alice B. Toklas* (1933), as well as her poetry collection *Stanzas in Meditation and Other Poems [1929–1933]* (1956). Written from the perspective of Stein's partner, Alice B. Toklas (1877–1967), *The Autobiography of Alice B. Toklas* is an autobiography of Stein herself and explores the couple's time in Paris, where Stein arrived in 1903 and remained for the rest of her life. There, she became deeply involved with modernist artistic culture. Her home in Paris functioned as a salon for many now-celebrated writers and artists, several of whom were her close acquaintances. Stein is also recognized for coining the term the "Lost Generation" to describe American authors living abroad, including Ernest Hemingway and Sherwood Anderson. She and her brother Leo were among the first collectors, patrons, and supporters of many modern and cubist artists, including Pablo Picasso, Georges Braque, and Henri Matisse. Her own work shares the goals of that of her contemporaries—for example, similar to cubist works, her writing shows a proclivity for simplification, repetition, and fragmentation. Revered and feared for both her literary and artistic expertise, Stein has, in no small part, shaped how we understand and appreciate modernism today.

LYNNE TILLMAN writes novels, including, most recently, *Men and Apparitions*; short stories, including the collection *The Complete Madame Realism and Other Stories*; and essays and art and cultural criticism, including contributions to the catalogues *Andy Warhol—From A to B and Back Again* (Whitney Museum of American Art) and *Raymond Pettibon: A Pen of All Work* (Phaidon and the New Museum) and publications such as *Aperture* magazine. In spring 2020, her short story "The Dead Live Longer" appeared in *n+1*. Her book-length autobiographical essay, *Mothercare*, is forthcoming from Soft Skull Press in 2022. Tillman has received a Guggenheim Fellowship and an Andy Warhol Foundation Arts Writers Grant. Tillman is a professor and writer in residence in the English department of The University at Albany. She lives in New York with the bass player David Hofstra.

THE *EKPHRASIS* SERIES

"Ekphrasis" is traditionally defined as the literary representation of a work of visual art. One of the oldest forms of writing, it originated in ancient Greece, where it referred to the practice and skill of presenting artworks through vivid, highly detailed accounts. Today, "ekphrasis" is more openly interpreted as one art form, whether it be writing, visual art, music, or film, that is used to define and describe another art form, in order to bring to an audience the experiential and visceral impact of the subject.

The *ekphrasis* series from David Zwirner Books is dedicated to publishing rare, out-of-print, and newly commissioned texts as accessible paperback volumes. It is part of David Zwirner Books's ongoing effort to publish new and surprising pieces of writing on visual culture.

OTHER TITLES IN THE *EKPHRASIS* SERIES

FORTHCOMING IN 2022

Dix Portraits
Gertrude Stein

Published by
David Zwirner Books
529 West 20th Street, 2nd Floor
New York, New York 10011
+ 1 212 727 2070
davidzwirnerbooks.com

Managing Director: Doro Globus
Editorial Director: Lucas Zwirner
Head of Production: Jules Thomson
Sales and Distribution Manager:
Molly Stein
Publishing Assistant: Joey Young

Editor: Elizabeth Gordon
Proofreader: Jessica Palinski
Design: Michael Dyer / Remake
Production Manager: Claire Bidwell
Printing: VeronaLibri, Verona
Typeface: Arnhem
Paper: Holmen Book Cream,
80 gsm

Dix Portraits was first published in
1930 by Éditions de la Montagne,
Paris, in an edition of one hundred
copies with ten original lithographs.

Distributed in the United States
and Canada by
Simon & Schuster, Inc.
1230 Avenue of the Americas
New York, New York 10020
simonandschuster.com

Distributed outside the
United States and Canada by
Thames & Hudson, Ltd.
181A High Holborn
London WC1V 7QX
thamesandhudson.com

ISBN 978-1-64423-054-1

Library of Congress
Control Number: 2021925170

Printed in Italy